LAST WALK

In late December 1999 I took a drive that was supposed to be about selling my business plan. I'd gotten a new car and had taken up with a couple of credit cards after I had worked a union job up in the mountains.

What ever was the story of "Happy Camper"? I never saw it.

Drunk I started out in the night overtaken with a change of plans and plans and everything in the car. I ended up at Ed's and hung out for awhile. He helped me change over to a thrown away computer from a Smith Corona 9050 Barbara had given me. I miss that word processor still.

My business plan was ahead of its time and nobody can see it or wants it still unless they are near death or engaged in killing people. There is more to it than that. The myth of America as vital because of its interconnectedness is bullshit as well. This explains why you have to go to NYC.

"There is no substitute for personal contact." – James Boy, Pilot President of Florida Aircraft Leasing.

I ended up on the loop back towards NC in NYC where I tried to make a few things work out, that didn't. They still haven't caught fire. I must live among the swamp brains. Zombies and Vampires are all around me.

I borrowed my friend's Nikon and took a walk and took these picture. At the time I called the set "Last Walk Series".

It has turned out to be literally *my* last walk in NYC from Stone Street which is off between Wall St. and Broadway over around up the recently completed Esplanade and up back around to then home. I'm not going to include my shot of the Bull. I am a little off on the order, but this is how I've gotten it done in between more important work that I need to get done.

I figured things would never quite be the same after the turn of the century. Things haven't been. Things have moved quickly which is explained according to the economist Thomas Piketty by *"Compound interest"*.

My life of art and crime is explained by *undercapitalization*.

Somewhere there is a perfect 16" by 20" B&W contact sheet of this I annotated in oil pen. The B&W printing lab Dalmation offered that and it was a great thing I put in a frame and had shown at a coffee shop down on Tate St. in Greensboro, NC. I was carrying it away when I was in College Hill a bar a few blocks up in the Green City neighborhood when I sold it.

I had often functioned under the misapprehension that people I saw once in a local bar, I would certainly one time see again.

So I sold it for 100 dollars, taking 50 there, and never seeing it again. If you have it, it is worth pretty good now.

I often went to bars to get out of the house. In the late 1990s after breaking up with Barbara I was back at Mom's and stayed there at the condo writing in the back utility shed next to the washing machine and the water heater at this long thin Formica table with little steel legs.

By then I was staying in motels as well. When I finally got the money up and found a little place I could afford, the landlord looked my credit score up on his computer and refused then to rent to me. He was a snarly mean little man in a gray suit. After that I stayed more and more in motels landing in one at the crossroads of I 40 and 54 where I stayed till I moved really all the way into an apartment in Chapel Hill.

There is a short book I wrote from that year. It is <u>Dangling Conversation, or Two Women</u>. I may or may not put it out. It is unique in regard to the way it was written over a one year schedule, and that was it. It is what I did for a year. A woman writer I had had a thing for was supposed to write an accompanying set to be joined with what I wrote. She never did. I don't care if I ever see her again.

The video "Contractors Creed", now up in my youtube channel Transcendian was made during this time. Most people find it very depressing. Reality Television is supposed to be trivial.

Lots of the time I live and work in Submarine spaces. Now isn't much different. However a long thin table is a fine work place, fits through doors and goes against the wall, and you can still sit there in a nice chair and work at a typewriter computer set up, which is what I did.
Since the advent of self publishing I have started to work through the "back catalog".

I have properties see.

Ed Hettig was of great help with what is now <u>The Revolutionary</u>. I am under no illusions that Amazon cares much really about books as moving forces in the mental landscape. <u>Homeless Dog</u> was the original title of <u>The Revolutionary</u>, putting it into a section of books about dog food.

What is sad about that is that many people are infected with a product mentality about how to treat books, which are really like people. It is like how you live with a painting on the wall as if it is your company, which it is.

The paintings and the books are your company before and after real people. I've often lived alone, or in ditches, up laying behind a billboard in rain.

Lots of people give way too much power to "the computer", as well.

"Well that's just what the computer does."
The computer is a part of a system that people made up to help other people live.

<u>Last Walk,</u> likely was the last walk for people that lived in Battery Park City and worked in the Twin Tower, World Trade Center.
One of the richest areas in the world where all the money swirls, and then there with places to live finally.

When I lived in the city, and especially on E. 11th it was like anytime I went out my door, I was instantly then, *At the destination*.

My local destiny work is to make shipping container places to live, like could have worked in Haiti, except that Haiti is corrupt. Corruption and War, keep people poor.

As goes Haiti, will so go the world.

But yeah, then I know how to build real cheap on difficult land now from my studies of Haiti. Myself and the engineers could figure it out. It is being done. I want myself to get a ship to dock as a place. It has been done.

I worked at scrapping a ship in ILM the year I tried to fit in with their movie scene. It is such dangerous world it isn't done hardly at all in the US anymore. They move old ships from Hong Kong to India where they beach them and rip them apart mostly now. They can easily lose 5 people to each ship scrapped. That's what I hear, and I can believe it having done the work.

Yeah, I am an artist. I maybe ought not have ever done any hard work. One terrible bit was when I was digging inside a house and then trying to be in the right frame of mind to deal with television producers. When your mind is in a ditch of mud dirt it is really difficult to hit the right confident tone.

UNTV though really failed, and fails, not because of Time Warner's greed, or UN Foundations disappointments. Or the cold calculations of Rhodes Scholar Bill Clinton, a great Republican, greater than any real named party supported Republican, with the gutting and end to Glass Steagall.

Well there went the 70s to the 90s, as we were run along and beaten by Richard Helms and James Angleton. We really have not got the truth of it all with so many killed in the Proxy war Vietnam was. The story of the US during my lifetime has been one of "failed morality and wasted courage". That's the sentence I summed up Russell Banks great novel <u>Continental Drift</u> with. It is the story of the US.

It was at night thinking about all the challenge of well: Tell me of a better way? Have you got a better idea?

The builders, architects and engineers, just move on, building. Engineers ought to be more cheery because of what they do. A leader as I aspire to be needs good and loyal engineers, and I am proud to be able to call some my friends. Ken's gift of a Ukrainian Submarine Captains Hats and coats inspired my wife to get me a sword. I mean I can look pretty fitted out, though I need to change the insignia some.

I've been putting off doing this book because I can't do it correctly. Each one of the photographs needs more credits to it. What exactly is the name of the street it is on? What is the name of the park?
I don't have the money to go back and walk the book of photos in hand making the proper notations, and or even putting it all in proper how I walked it order.

If one of you, or a group gets so inspired to do the Last Walk, like it ought to be, like a Last Walk Tango, and yeah, yeah, get the thing properly annotated and then sent to me with the info so I can add it in properly, then that would be fantastic! We could make a deal.

The best would be to get pictures of how it looks now and combine them.

Russell Scott Day 7/25/2014

Written from my desk in Carrboro, NC

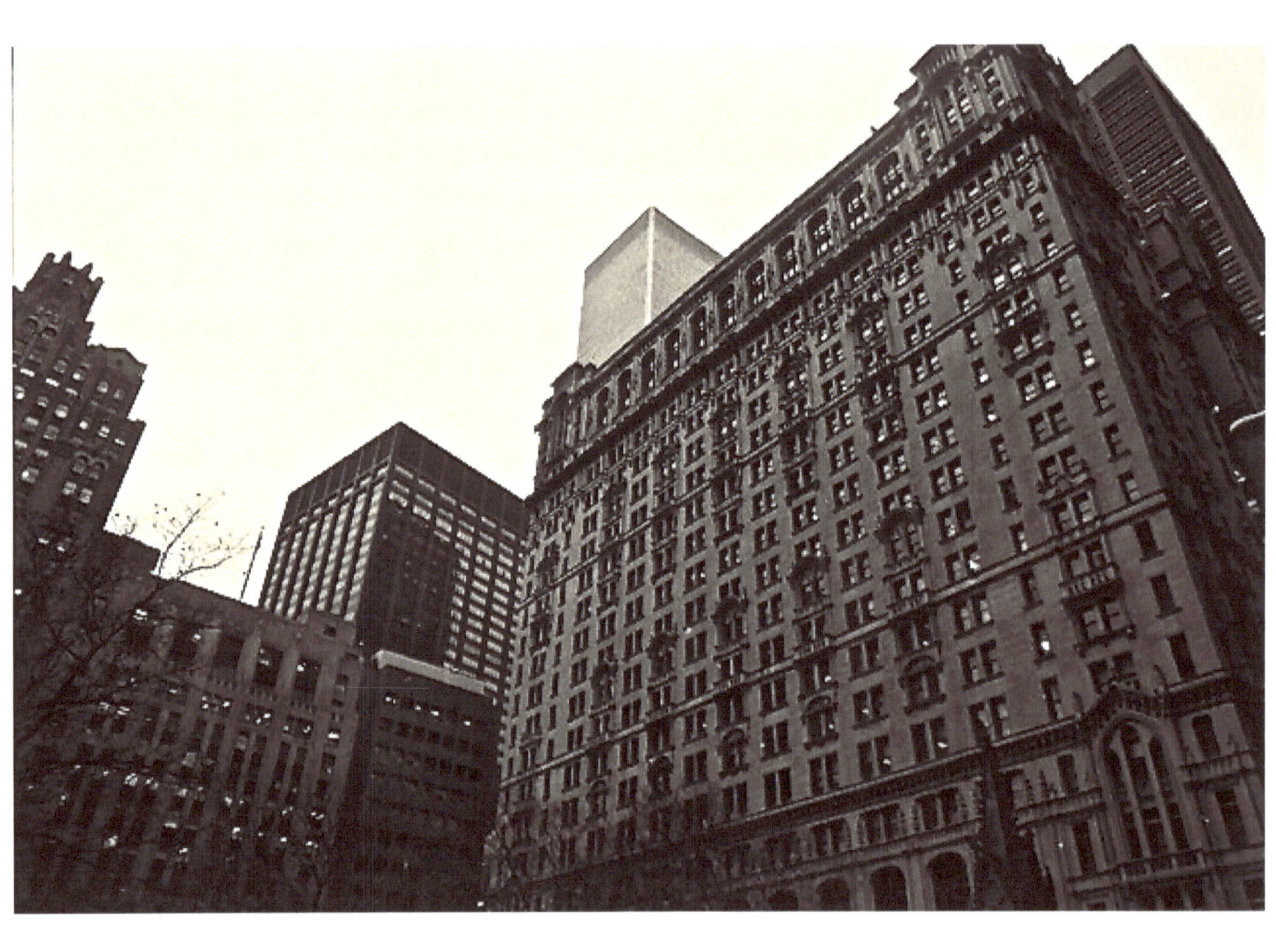

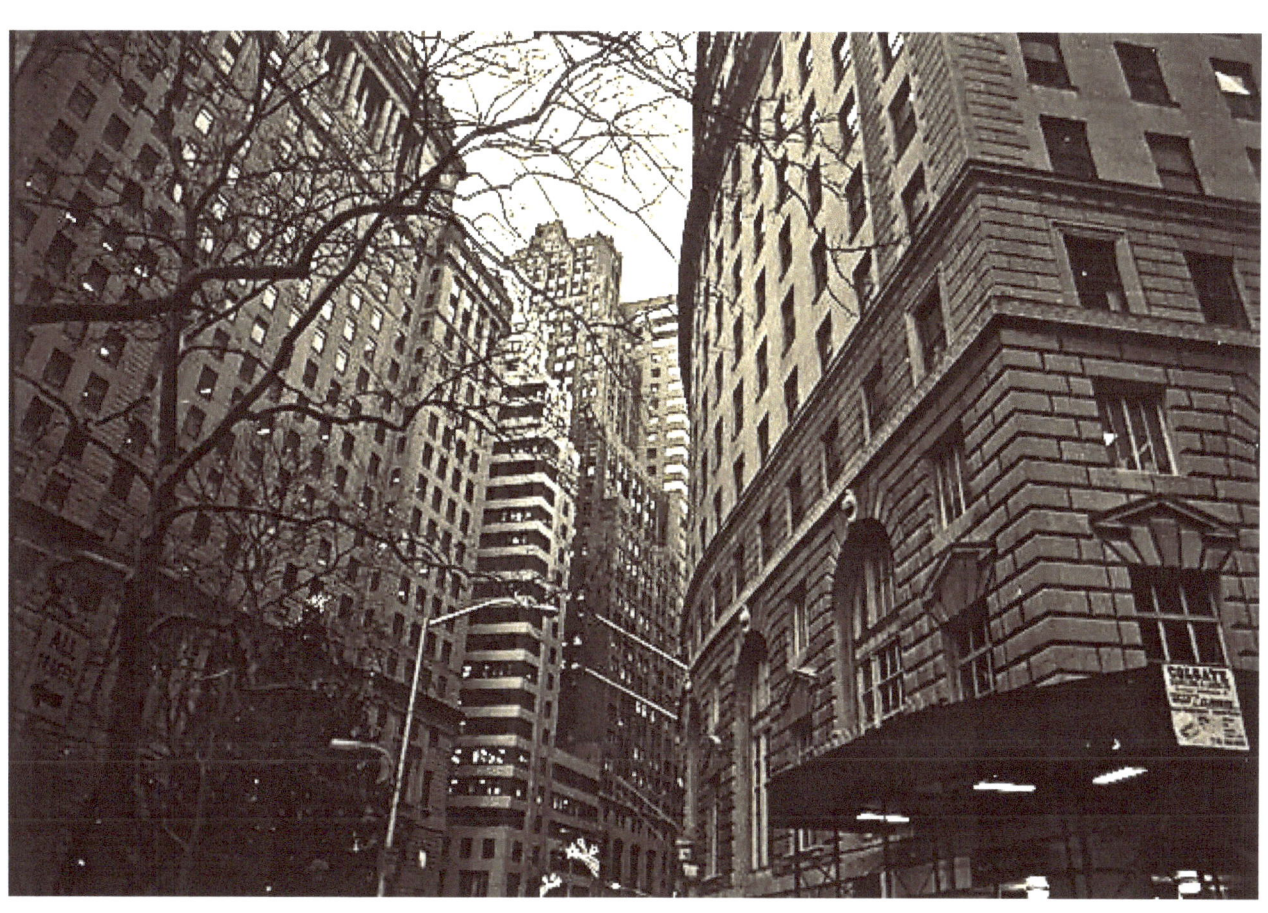

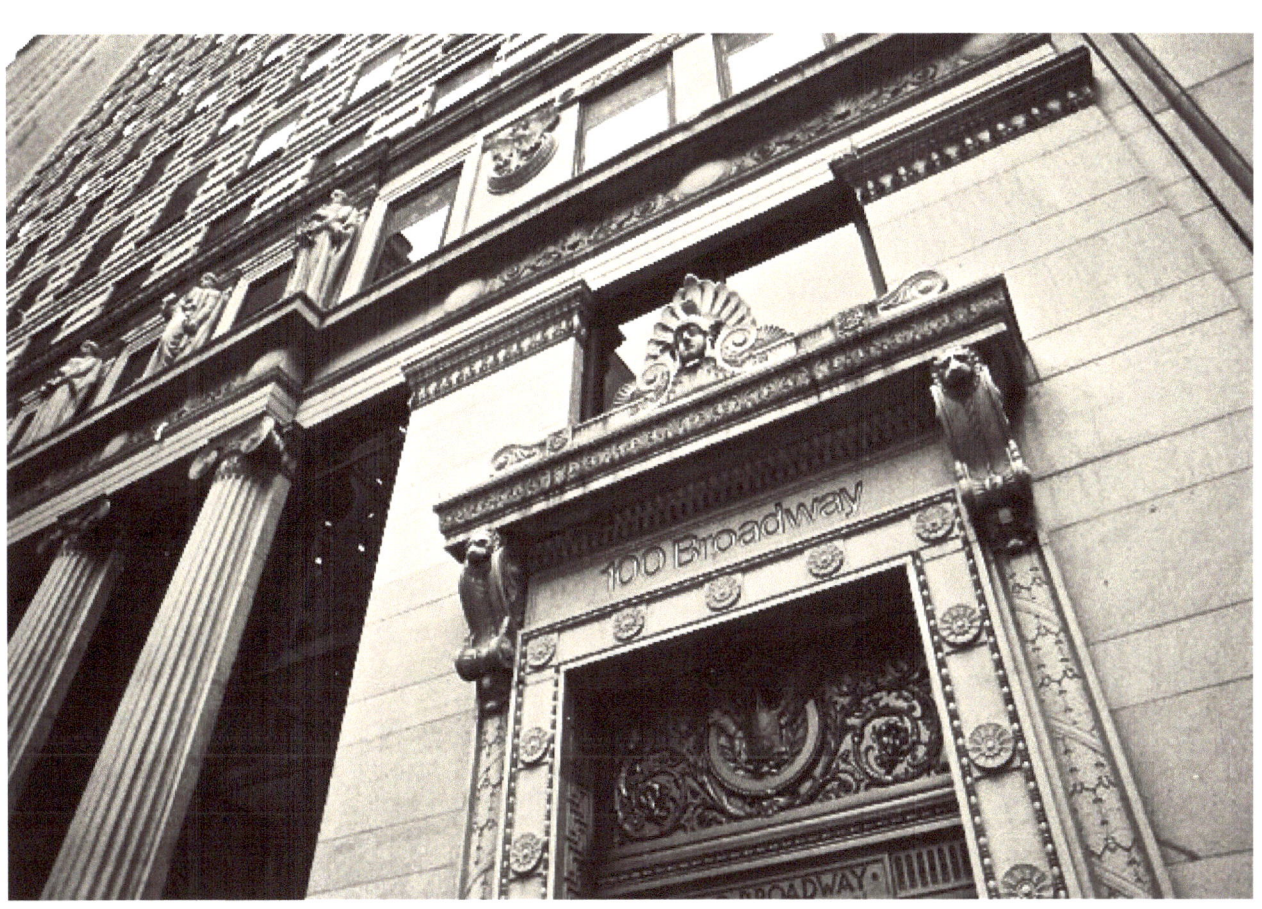

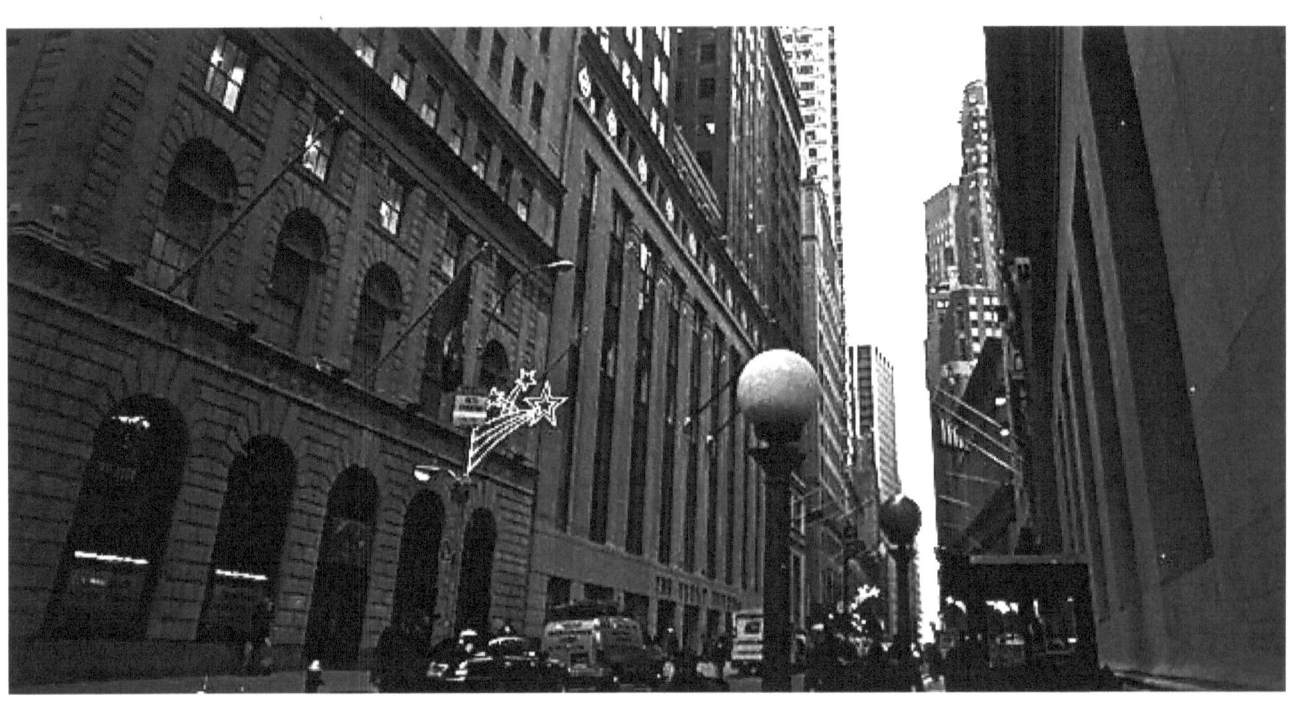

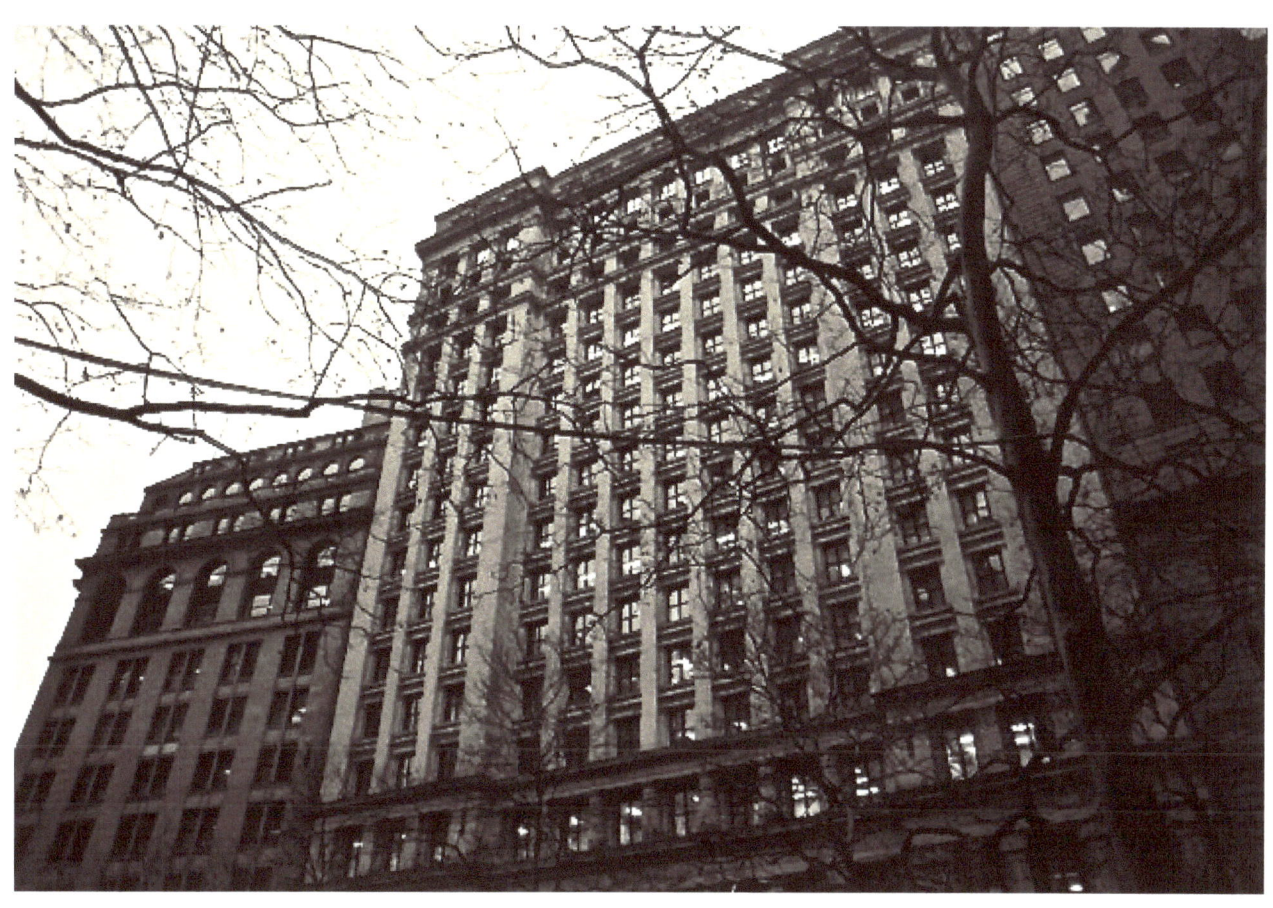

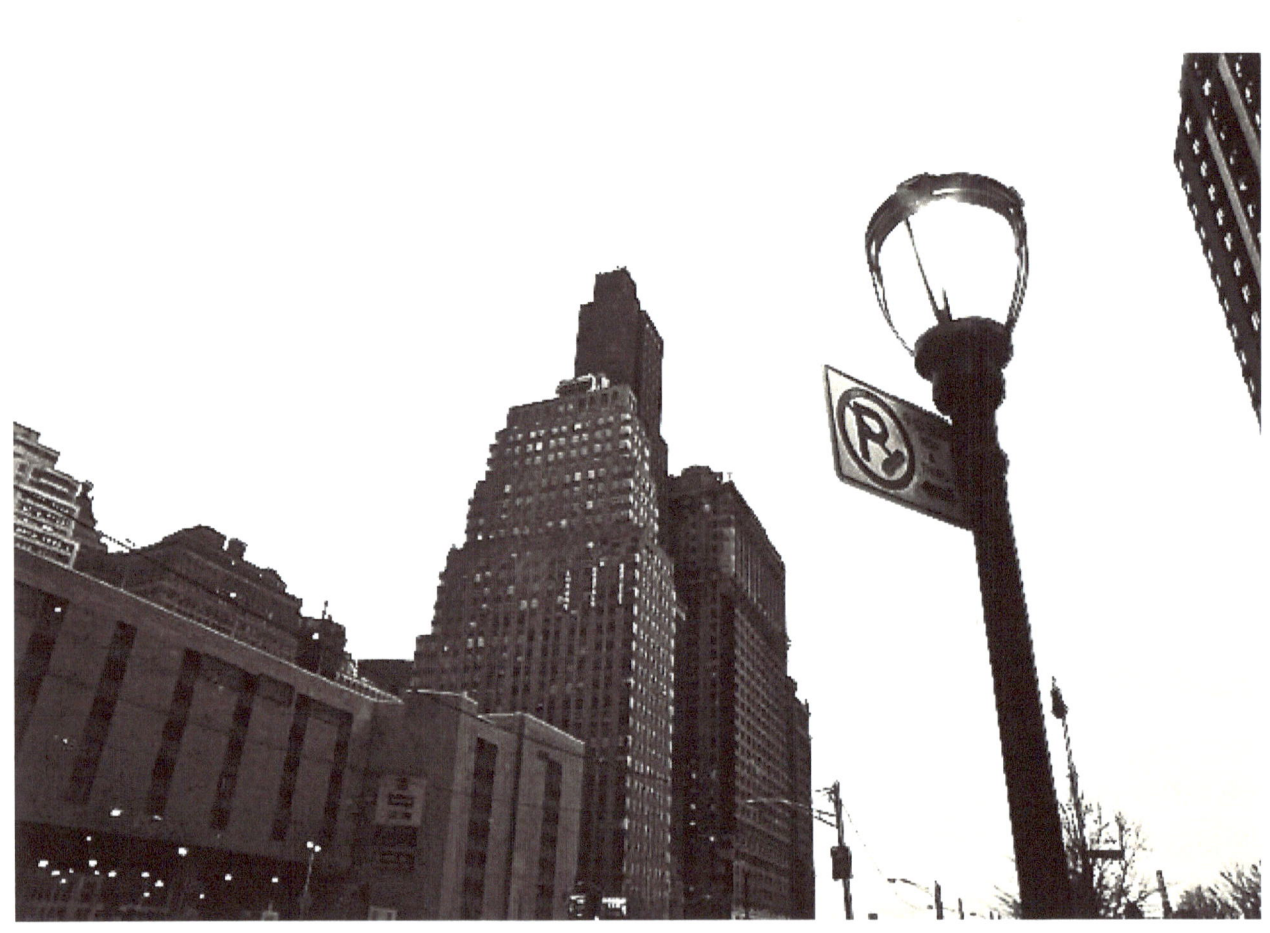

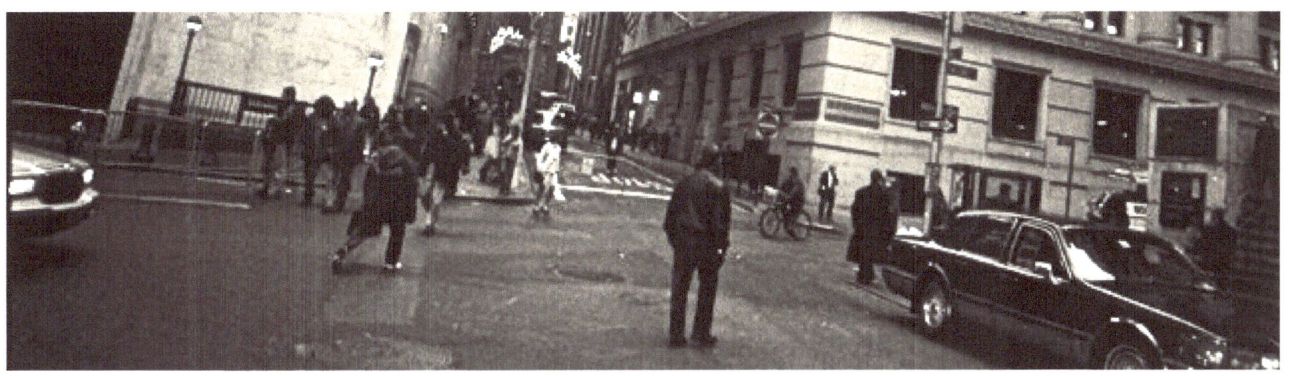

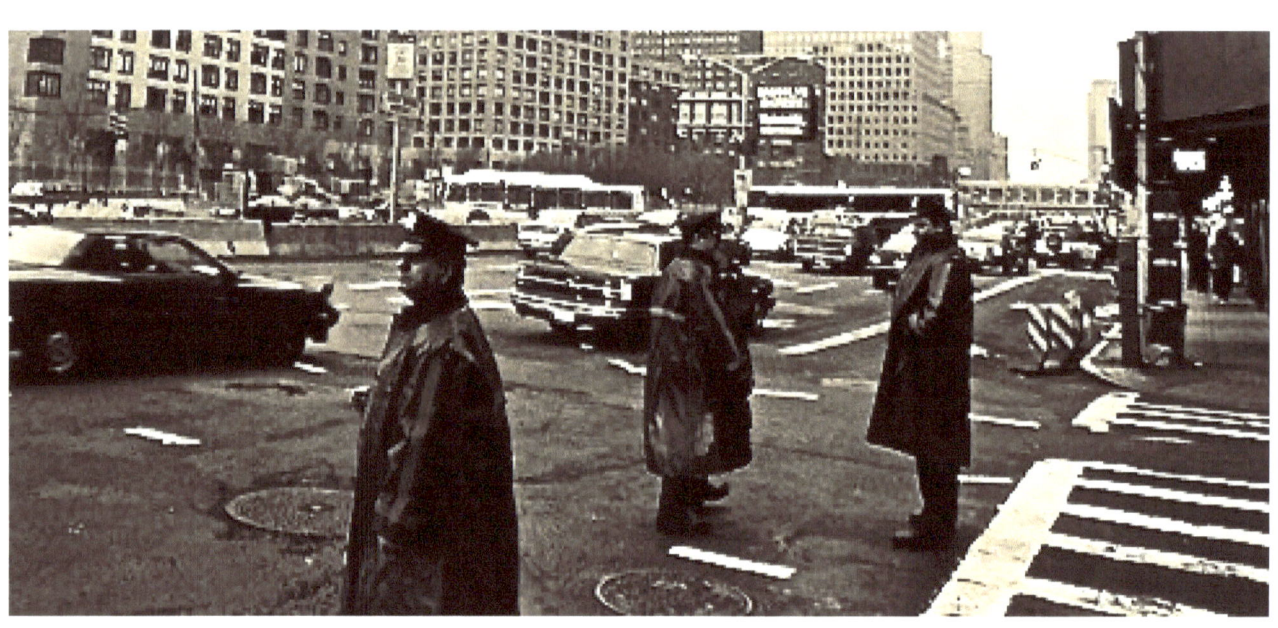

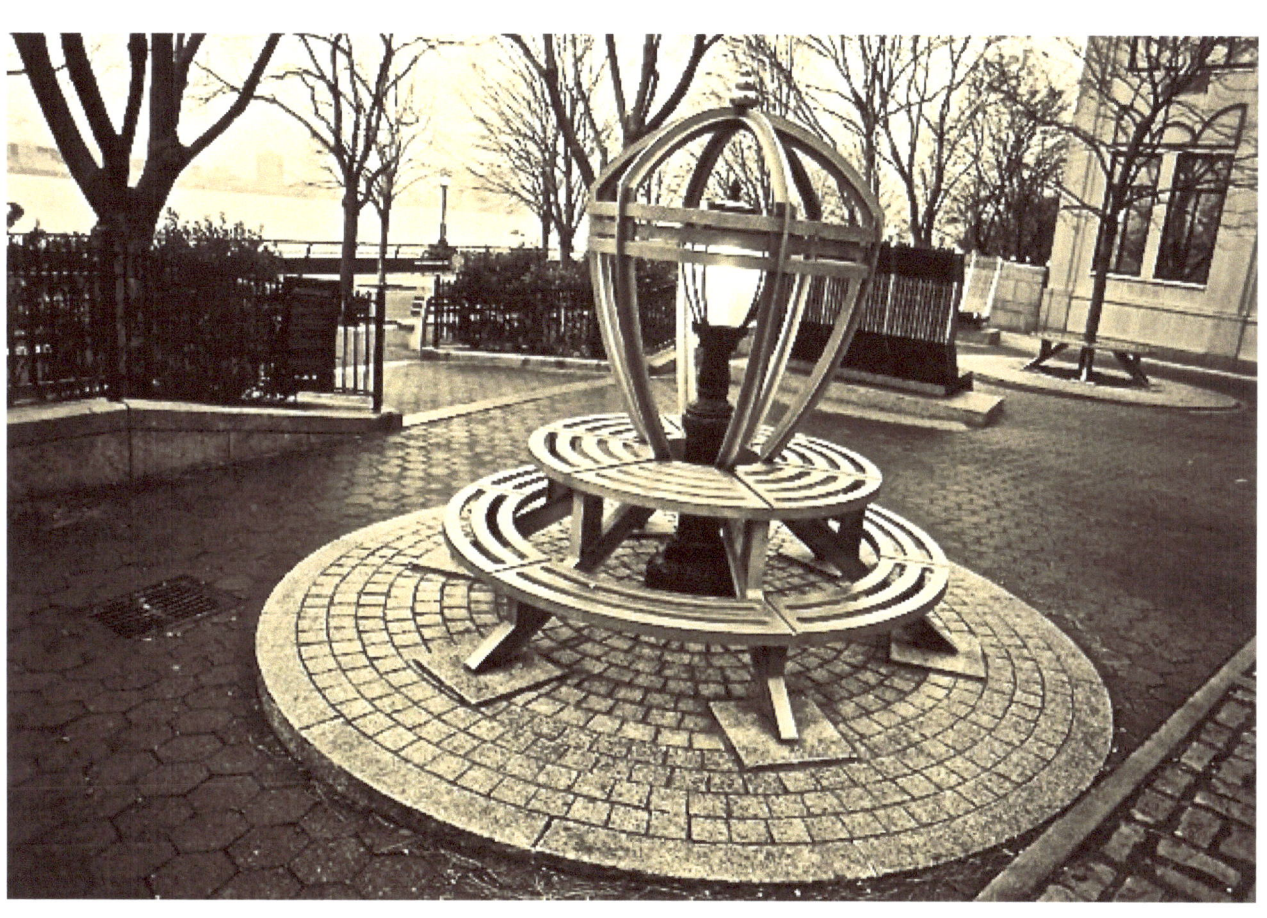

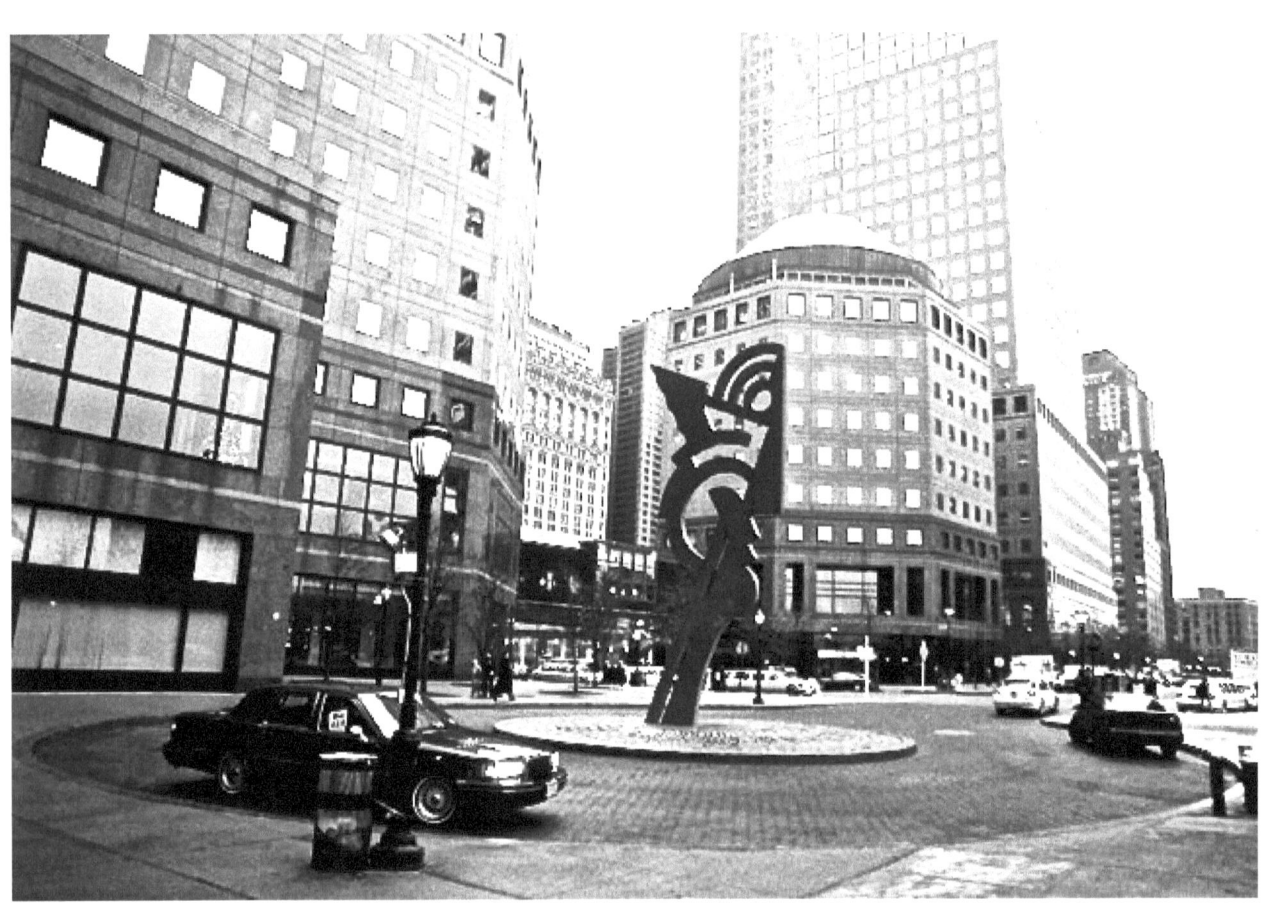

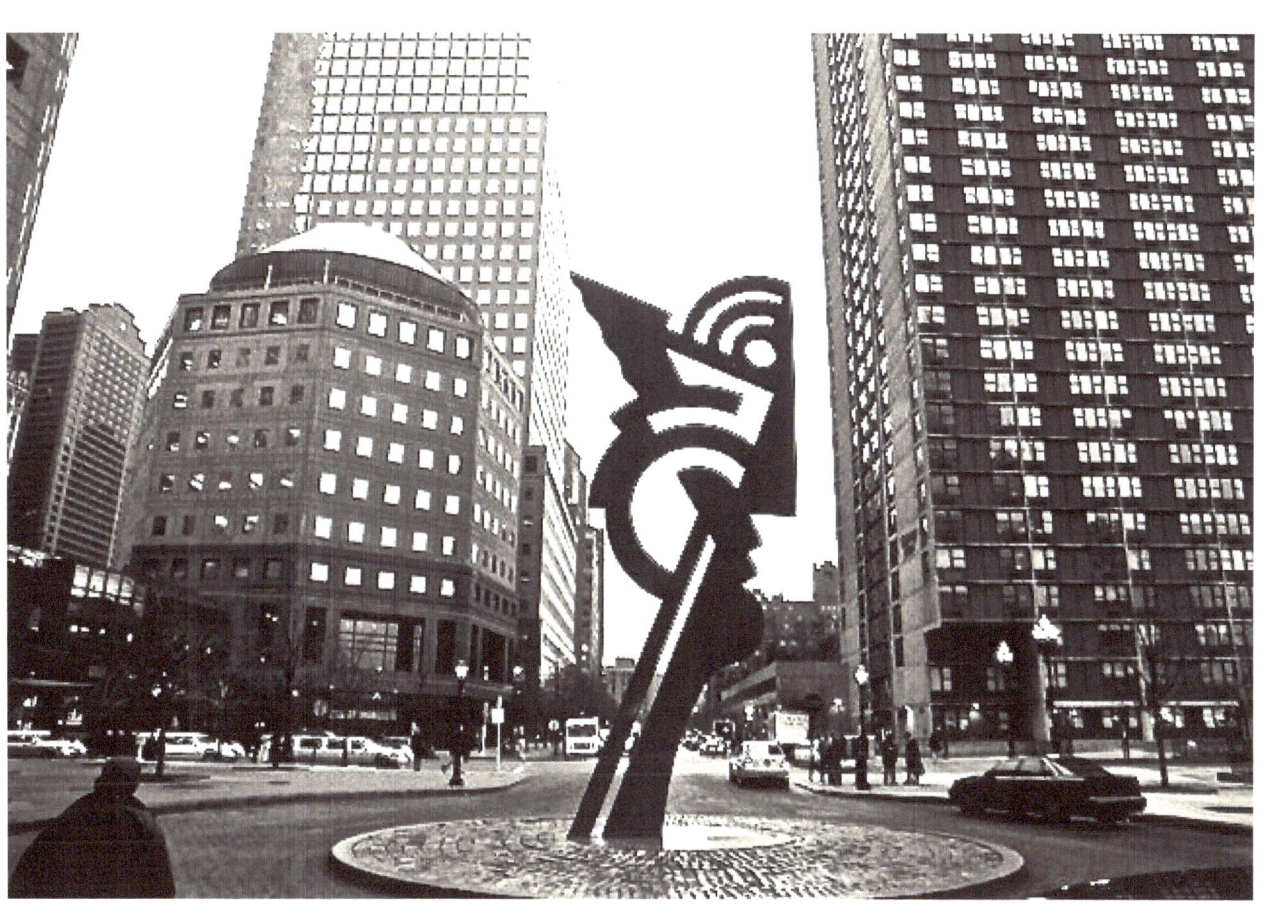

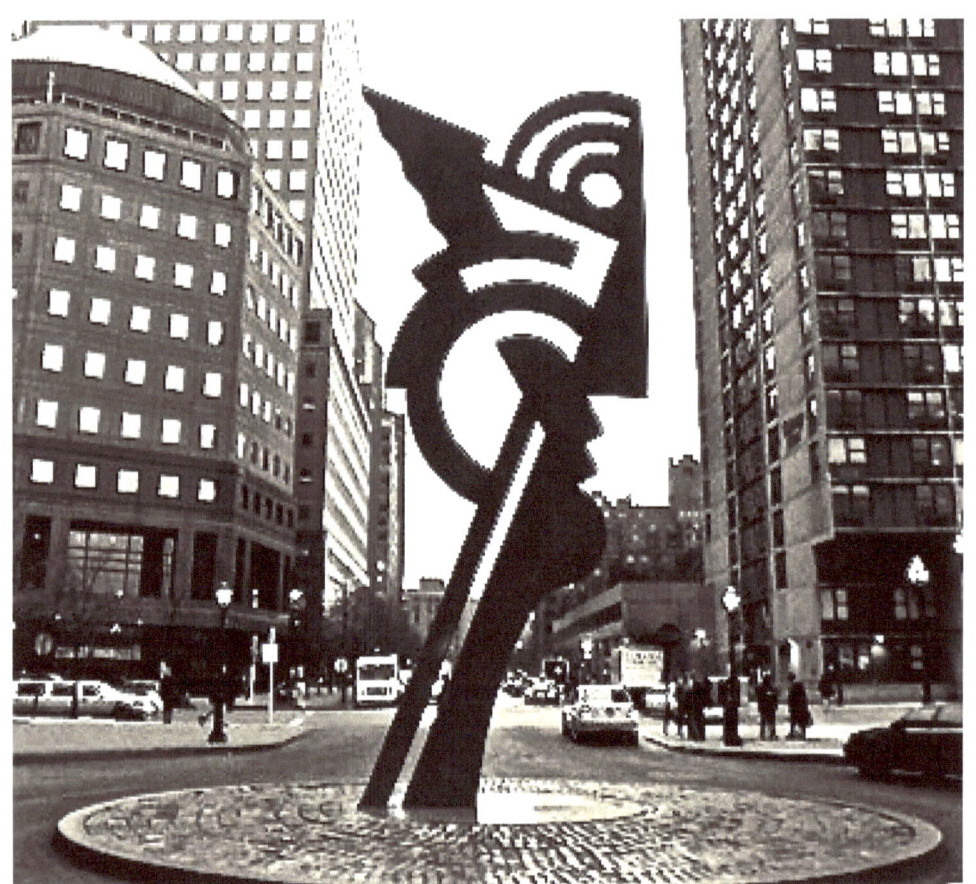

Modern Head,
Roy Lichtenstein

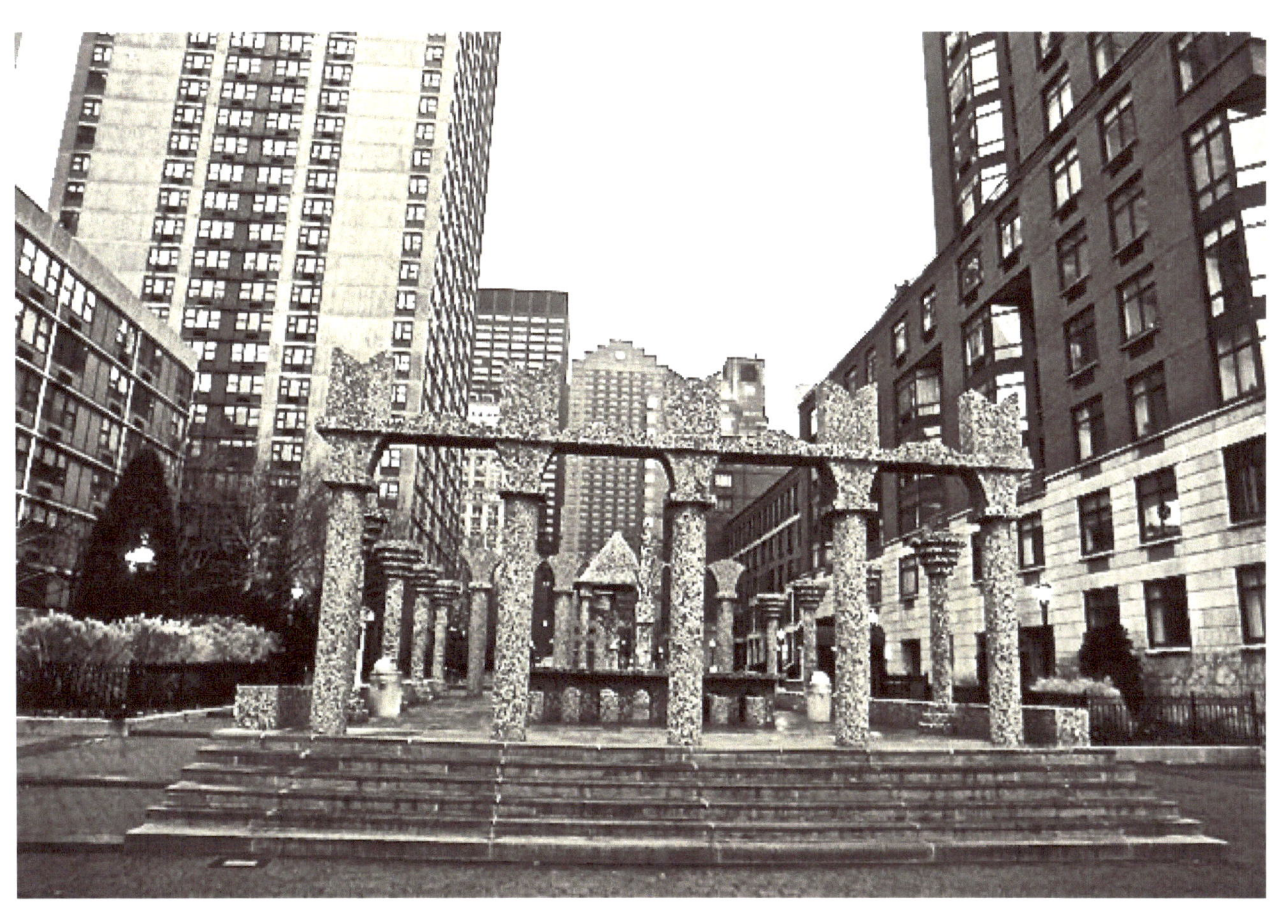

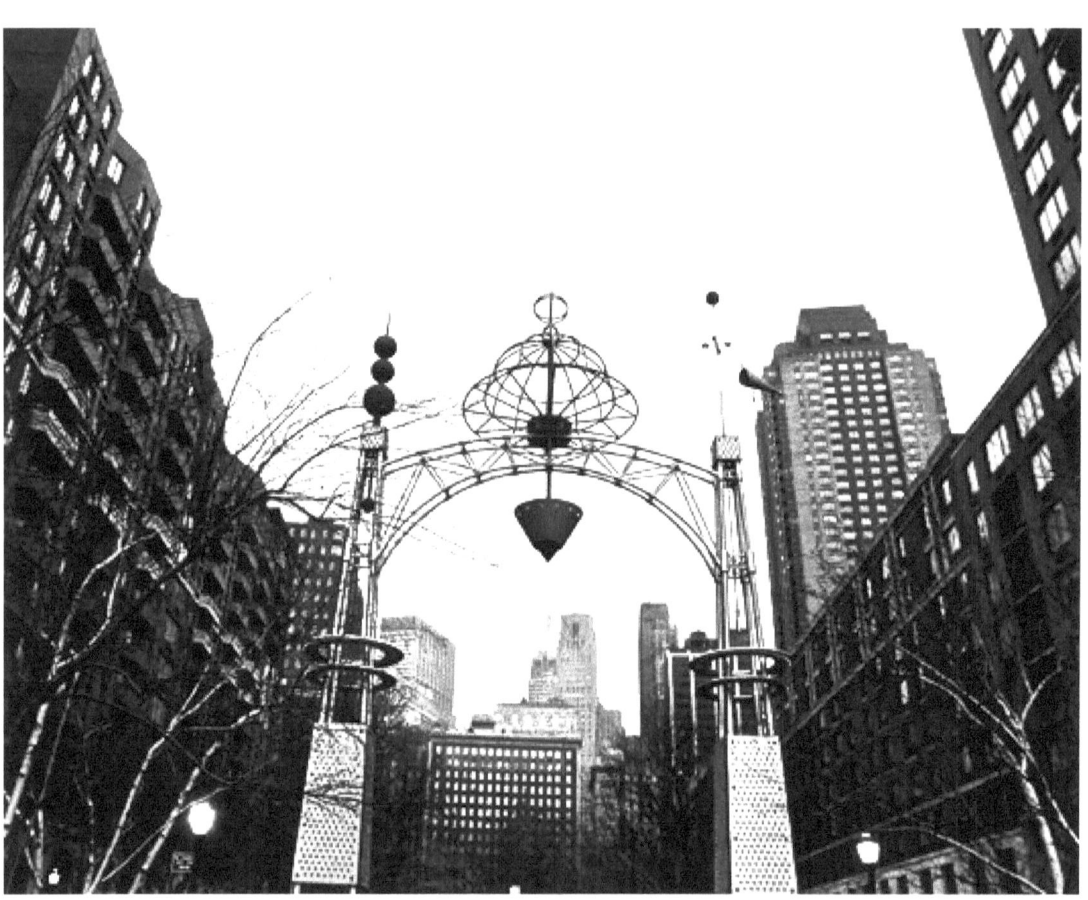

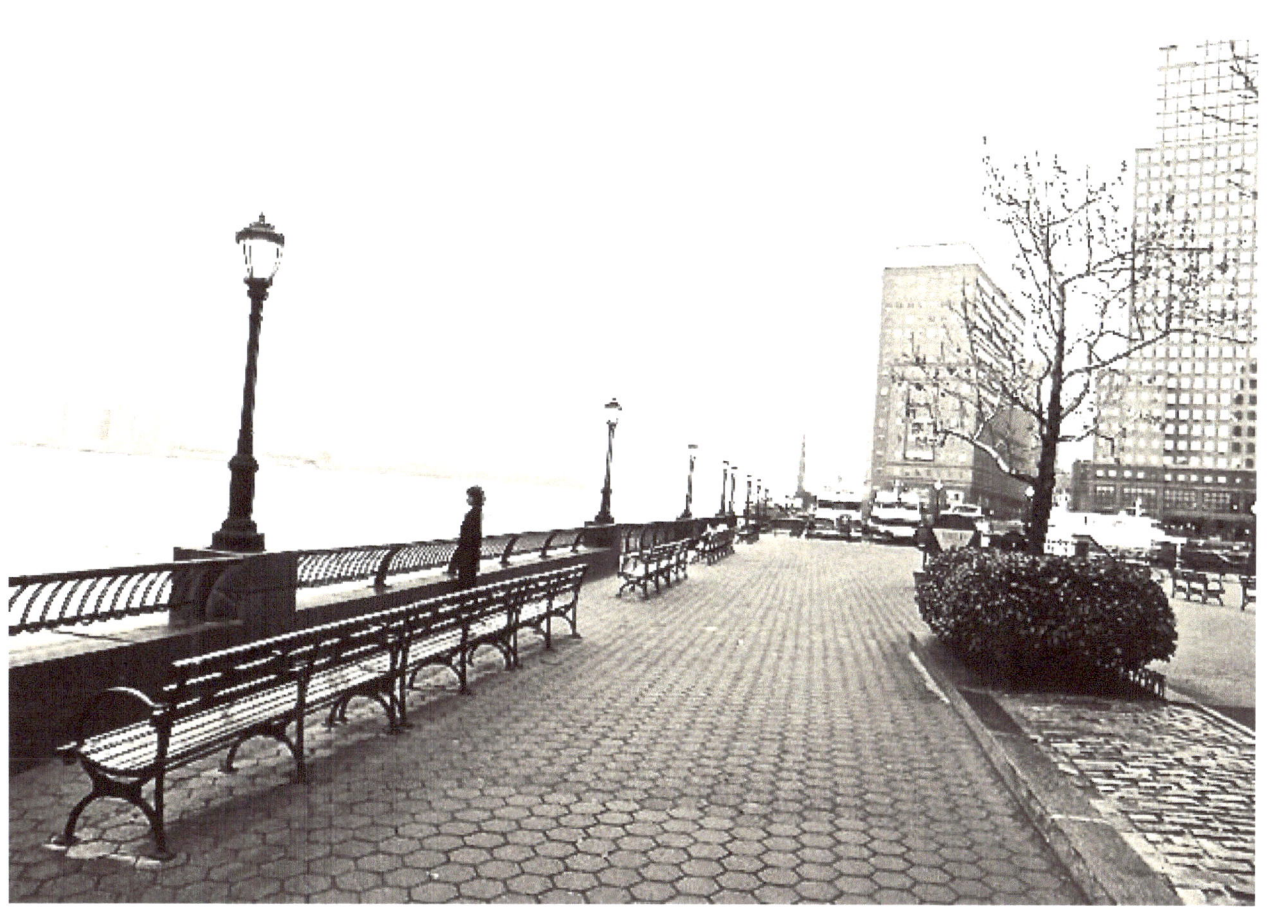

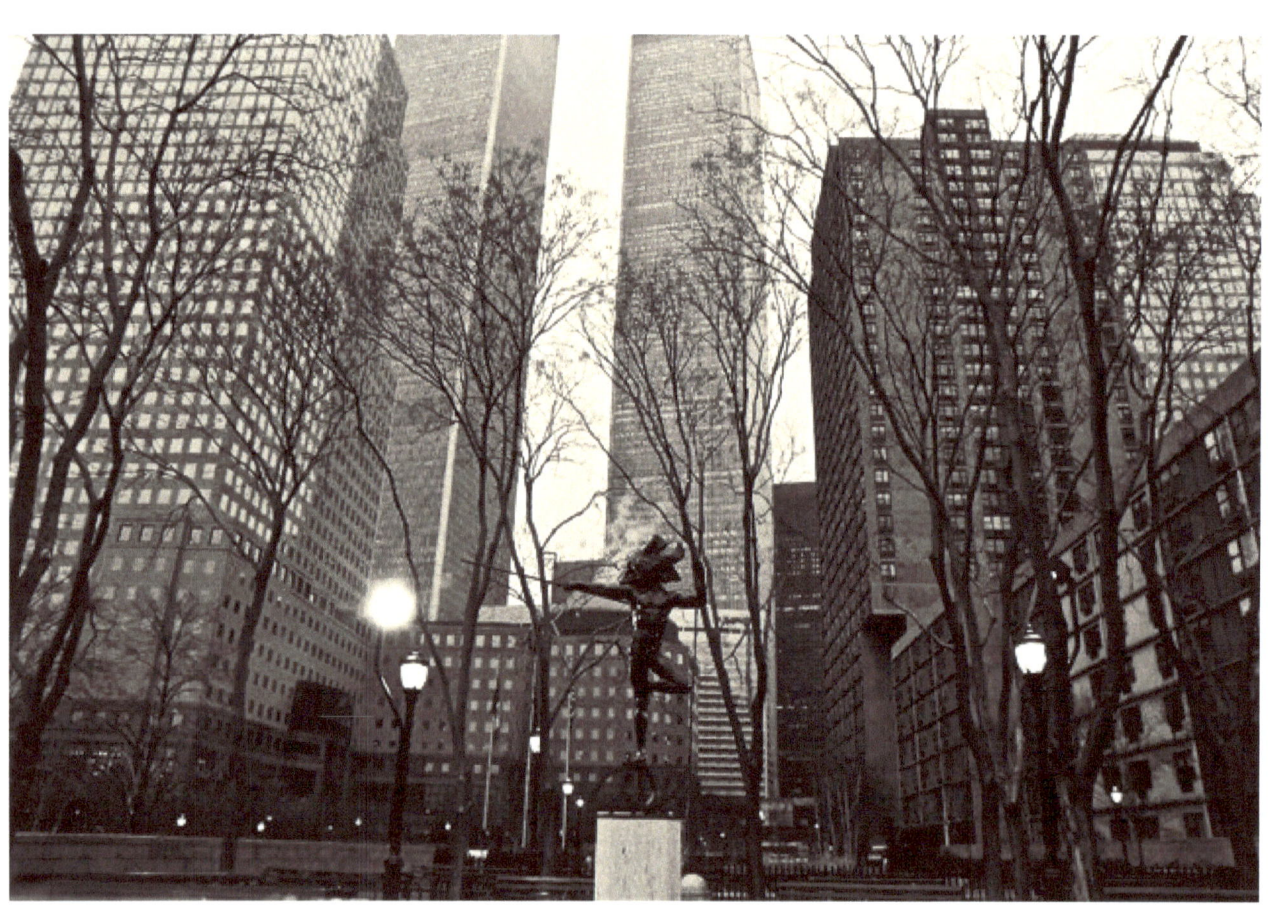

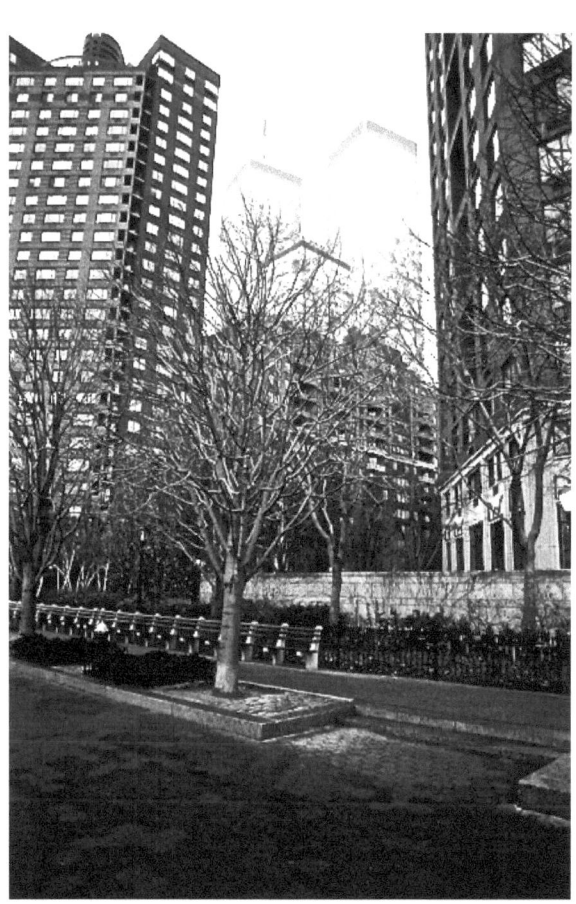

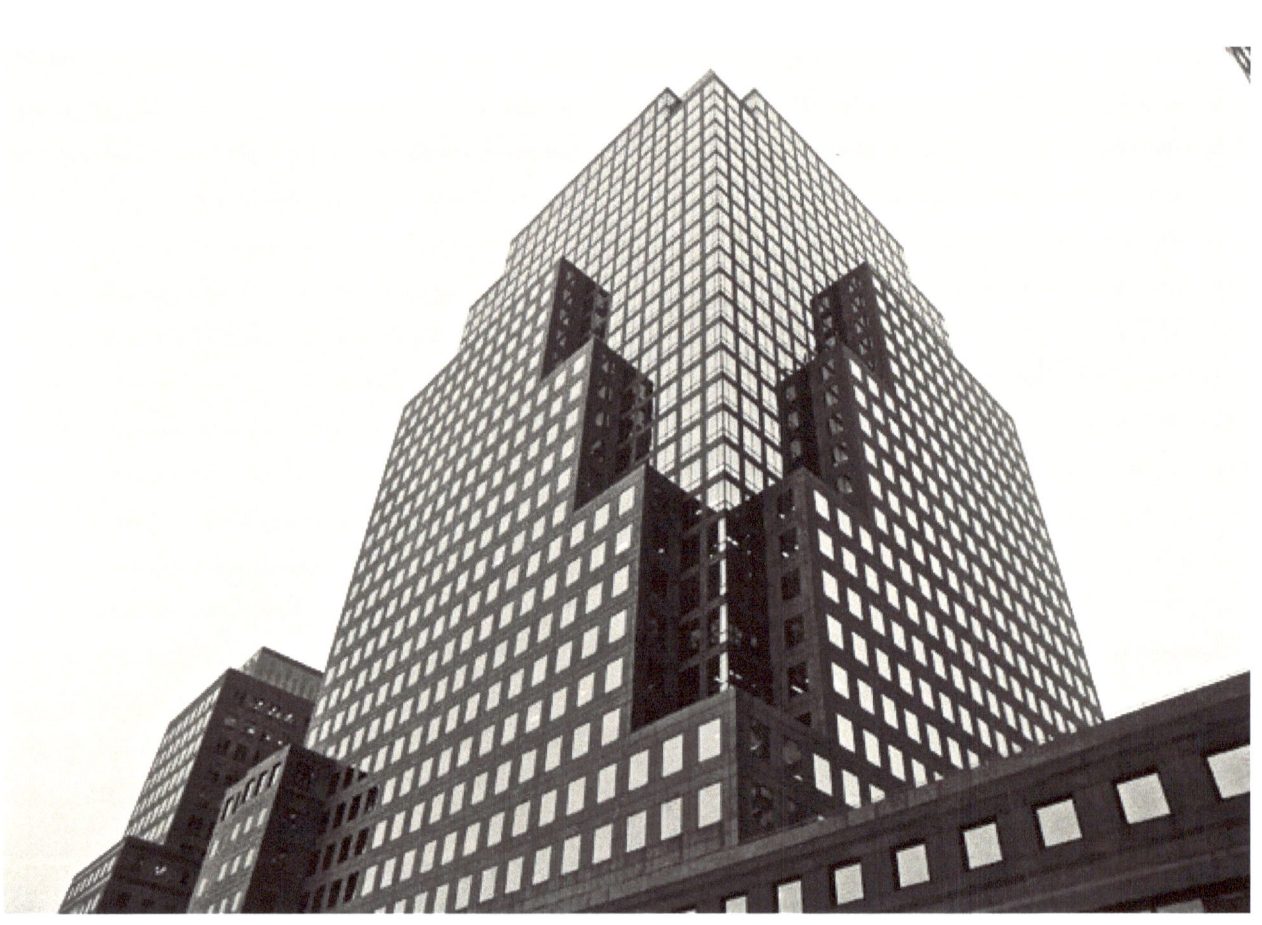

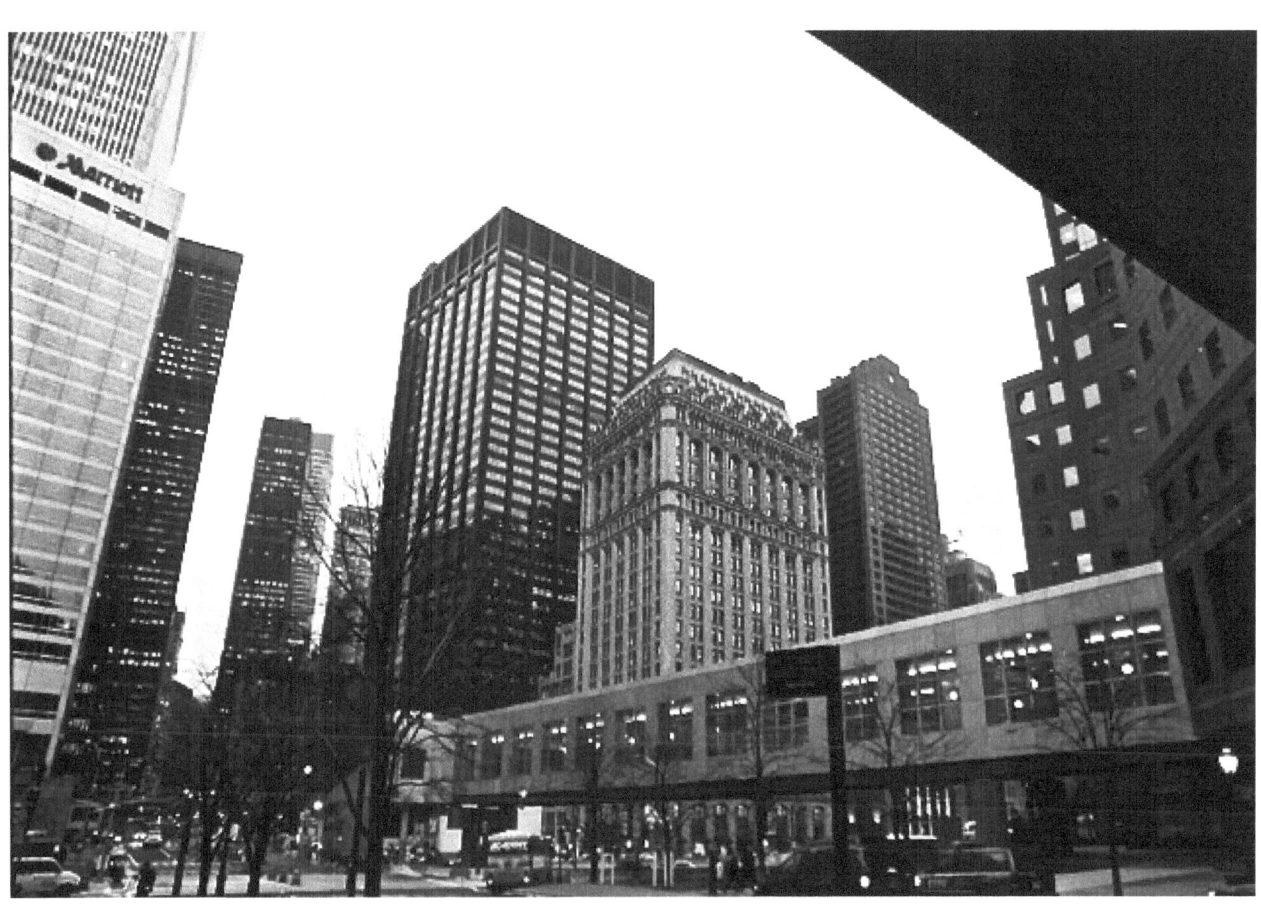

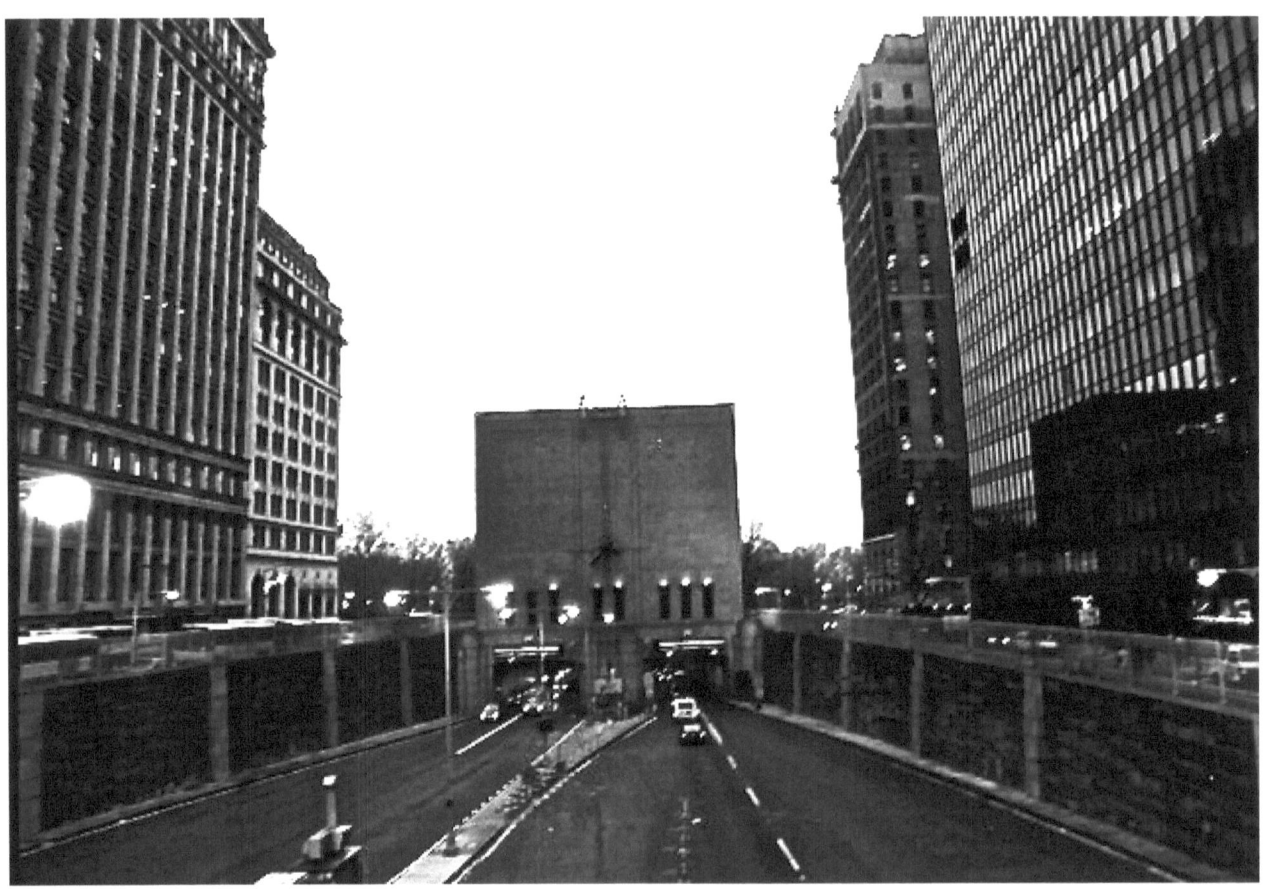

Thanks

Other publically available works are: <u>The Revolutionary</u> an e book, and an audiobook

"Psychiatrists Love Insanity" a book of poems.

Transcendian Passport Everyone needs more than one passport. Some people need to be given some papers and be set free to travel to live and work where it suits them.

Transcendia Passport I made two of them. Since I haven't got a group of bureaucrats working for me, the best ones are the ones I have signed, and there are only about 300 of those. Those are really rough looking. There are pilot heroes like Jim Monahan, who died in a reverse trim flight of a Convair 440. The heroic pilots of the Berlin Airlift, and some too many lost in the Cold War deserve these passports. Pilots don't really talk much. I am ground support, though I can get one there and about in a pinch.

www.ingramcontent.com/pod-product-compliance
Lightning Source LLC
Chambersburg PA
CBHW050426180526
45159CB00005B/2428